LOST BASILDON

LISA HORNER

AMBERLEY

First published 2019

Amberley Publishing
The Hill, Stroud
Gloucestershire, GL5 4EP

www.amberley-books.com

Copyright © Lisa Horner, 2019

The right of Lisa Horner to be identified as the Author
of this work has been asserted in accordance with the
Copyrights, Designs and Patents Act 1988.

All rights reserved. No part of this book may be reprinted
or reproduced or utilised in any form or by any electronic,
mechanical or other means, now known or hereafter invented,
including photocopying and recording, or in any information
storage or retrieval system, without the permission in writing
from the Publishers.

British Library Cataloguing in Publication Data.

A catalogue record for this book is available from the British Library.

ISBN 978 1 4456 9257 9 (print)
ISBN 978 1 4456 9258 6 (ebook)

Typesetting by Aura Technology and Software Services, India.
Printed in the UK.

Contents

	Introduction	4
1	Shopping	6
2	The Working Day	28
3	Transport	49
4	Leisure and Activities	61
5	Entertainment	82
	Bibliography	95
	Acknowledgements	96

Introduction

Life in the villages of Laindon, Langdon Hills, Lee Chapel, Basildon, Vange and Pitsea before the new town of Basildon was built after the Second World War was very different from today. Everybody knew everybody, and children could go out and play safely. The doctor would come out to you and may have known you all your life. There were little shops and you knew the owners and assistants by name. It was a slower pace of life and there were more open spaces. It is understandable why people feel sentimental about the past. Sadly we have lost farmhouses and manor houses that were several centuries old, all knocked down in the name of progress.

Pat Mundy remembers when the Basildon Development Corporation compulsorily purchased their piggery off Laindon High Road for a pittance in *c.* 1954. They then purchased land that went from Burnt Mills Road to well on the way down to Pitsea. Pat, her husband Ronald and their two sons then set up a demolition business and were qualified weighbridge operators. They couldn't believe it when the Basildon Development Corporation wanted to compulsorily purchase more than half of their land and business. Ten bailiff vans arrived that day, and the land was taken where their 60-ton public weighbridge stood, which was used by the local authorities.

David Coubrough recalled that growing up in Pitsea was an adventure every day. In the summer there was swimming in the creek and the side pools; he reminisces that it was a beautiful place then – no refuse tip, no sewer works and the banks were covered in wild lavender and heather. What is now the Wat Tyler Country Park was an arms dump after the war, and they used to love sneaking in there under the threat of being caught and playing with the old army equipment. They used to go scrumping; there was an abundance of orchards around Pitsea and they would help themselves to apples, pears, plums and greengages. These were all for the taking, as long as the farmer never caught them, otherwise they would end up with a clip around the ear and a good telling off. Very rarely did they get threatened with the police; instead they were told their parents would be informed, which would instil them with panic. Nobody worried about you like they do today, recalls David, it was a safer world to be in.

Tom King, former chief features writer for the *Evening Echo*, remembers that before the new town development Basildon was a semi-rural setting with scattered bungalows, dated houses and a lots of small, rough farms – mostly dairy. Some of them still used horse-drawn carts and supplied milk locally within a mile or two, and to the London market. Tom said, 'If you want to feel what old Basildon was like you only need to drive to the Five Bells roundabout where the A13 goes off to Vange.

Tom has lived in Wickford, in the borough of Basildon, since birth. In 1954, when he was around five, his mother and father said, 'We're going to go and look at where there is going to be a new town.' So they went up on the ridge between Billericay and Wickford and looked down across the A127 to Burnt Mills, to where Basildon was

rising up. They took him around all the sites that were earmarked for central Basildon. It was actually visible, emerging from green fields as he grew up.

Tom lived in Belmont Avenue, Wickford, which was a mud track. His dad used to work in Romford, and he'd often get his Morris stuck in the mud on the way home. One thing they used to do each year was to collect all the cinders from the coal fires. Everybody used to pile out and cover the roads with them. It was a place of blackness, a very scruffy and haphazard area. This is why many, like Tom, appreciated the spirit behind the Basildon Development Corporation, as everything started to look a lot better. An awful lot of people lived in slums in London in very poor conditions, but Basildon was giving them a new break.

Geraldine Evans first heard the name Basildon around seventy years ago when her primary school teacher wrote it on the blackboard and told them to learn to spell it, as from then on it would be the name of their town. The people from Basildon adapted and coped as changes came. Many felt they were part of a great experiment. Basildon new town has now reached its seventieth birthday, it has a strong economy and there is a regeneration going on in the town, but it has a lot less green space than it used to as the country's urban sprawl continues to encroach upon it.

I

Shopping

Allders Eastgate closing sale, 2005.

Gales Stores at the junction of Bull Road (now Clay Hill Road) and Timberlog Lane, Vange, 1910. Geraldine Evans was born in Vange in 1945. She once counted all the small shops and communities from The Barge Inn down to Pitsea station and was staggered by how many there were: 'When you had all those shops you had such a vibrant community that knew each other and children were safe to wander about.' Below is Vange Post Office in 1918.

T. ROWE.
Woodleigh Dairy, High Road, Vange.

Purveyor of High Class Dairy Produce.

New Milk Delivered Daily.

Theodore Rowe purchased a dairy and milk delivery. His shop was on High Road, Vange, and is pictured here in 1920. Joyce Whitelock remembers many shopkeepers in Vange in the 1950s. There was Mr Conduit (chemist), Doughie Saunders (baker), Mr Bedwell (menswear), Mr Bell Fontaine (jeweller's), and Mr and Mrs Bews (florist). The Ministry of Labour and the Busy Bee Café were next to Evelin's the Haulier, which was run by the brothers Ernie and Reg Evelin, who were related to Joyce. Right by this was the Working Men's Club.

Joyce Whitelock remembers going to Mrs Smith's Tuck Shop on her way back from Vange Primary School. She thought the people were really nice. They had the sweets on a low shelf so they could get them easily. The picture below is of the Wayside Stores on the east side of Rectory Road, just north of Kenneth Road, in 1945.

A view of Pitsea High Road around the early part of the last century. Below we can see Churchill Johnson Ltd, which was a builder merchants and general ironmongers in London Road, Pitsea, from the 1920s to 1964. The company's head office was in Laindon, and it also had stores at Wickford, Billericay, Rayleigh, Hockley, Chelmsford, Brentwood and Grays.

Edward and Margaret Bostock ran Bostock Tobacconists in London Road, opposite Rectory Road, Pitsea. W. Newman (Westcliff-on-Sea) Ltd stood on the corner of the Broadway, Pitsea. It was a hardware and domestic store from 1931 to around 1945. In the foreground is the war memorial contributed by Harold George Howard, a farmer and landowner who was responsible for the Tudor architectural style of Pitsea. Later on it was moved to Howards Park, which he also gifted the town.

Allen's Fish and Chip Shop on the left of Timberlog Lane, Pitsea, which also sold wet fish. Many of the shops at the old centres – Laindon, Vange and Pitsea – suffered as new business was drawn into Basildon town centre as it developed. Parade Café, Reklaw and Miriam the hairdressers stood on the east side of Station Road, Pitsea, c. 1950. You can see the words 'Permanent Waving' and 'Hosiery' advertised on Miriam's window.

Butler's Grove House, Langdon Hills. 1920s

W. H. Smith, tobacconist, confectioner, draper and general stores (not be confused with the retail chain store) at No. 3 Butlers Grove House was on the High Road, Langdon Hills *c.* 1920. Its proprietor was William Hutton Smith. Below we see a very unique shop, the Dolls Hospital, which was built and run by Thomas Robinson in the High Road, Langdon Hills, in the 1920s.

The top picture is of Peperell's (newsagent and tobacconist) on the High Road at Langdon Hills. You can see a Howard's Dairies milk float along the road. The Dry Street Post Office and General Stores was open between the 1930s and the 1940s. Originally it was the Red Cow beerhouse, also known as a coach house, and was built in 1843.

Laindon High Road in 1905. Its unmade surface was deplorable in the winter when rain made it a slippery surface, and also in summer when the yellow clay topsoil would crack. Tea, Coffee & Cocoa Rooms is next to an entry to the rear building with accommodation above. Then there is a fruiterer and greengrocer and beside that is Taee's Railway Boot Stores, which sold footwear. There is signage above the greengrocer for Mr Foulger, who sold plots in Laindon.

Primrose Café, Laindon, 1920s. Plum duff was one of the puddings that would have been served. They would have had a paraffin oil cooker, perhaps a 'Little Rippingale' and gas for lighting and heating. The café also doubled as a tobacconists. Below we see Cottis Bakery and next to it a second-hand shop c. 1948 taken from the Laindon Hotel car park. Mr Cottis had lived in Laindon since 1908 and had two shops there.

Mabel Sloper and shop assistant Liddie serving in W. J. Sloper & Son, dairy and general stores, which was a dairy and high-class groceries and provisions shop. Mabel would wash all the bottles by hand five days a week, including 1/3rd pint bottles that were delivered to several local schools with cardboard lids that were pierced with straws. Mabel and her husband Sidney Sloper (see page 36) were fondly remembered. A newspaper article commemorated Mabel as an 'Old Laindon Pioneer' when she died in 1998 aged eighty-seven.

In 1956 Don's Cycle Shop, Laindon, may well have been a target for the Basildon Development Corporation. It was the planning chaos and unmade roads that drove Billericay Urban District Council to make a bid for a new town. Peter Sloper always went to Lodge Stores after his day at Markham Chase School and bought sweets and a glass of lemonade for a penny. Ted Lawrence is seen outside his store with a young customer.

Peter Sloper recalls that in the 1960s, Chas Markhams Dairies was on the High Road on the corner of Somerset Road next door to Dane Dye Works Ltd, the dry-cleaners. Then there was W. H. G. (Bill) Barrett, hairdressers. Further on was Laindon Memorial Hall, Sidney Hayden & Sons, then Fen Homes Ltd. A little way down was the Laindon Recorder office, next to Laindon Fire Station. Below is a thriving Laindon Shopping Centre *c.* 1990.

When Laindon Shopping Centre opened in 1969 some were saddened as shops in Laindon High Road were already disappearing due to Basildon new town. Then again, many thought it was a vibrant hub of the community, but in recent years only a few shops remained open. Swan Housing Association is transforming it into Laindon Place during 2019, a development of new street-facing shops and new homes. Below, we see Basildon Post Office in the then village of Basildon.

Here we see Basildon Stores, Church Road, in the 1920s. There is an A-board outside the shop with an advert for 'Lyons Fruit Pies'. Oxo is advertised on the top of the windows. Below we see the new shops in East Walk, Basildon, in the 1950s. This view is before Brooke House was built in 1962. You can see the huge contrast in style between the early building and the 1960s modernist style of architecture.

Woolworths had been in Basildon town square since 1960 – a familiar institution. It was a shock to the country when the company ceased trading on 27 December 2008. Shopping trends have changed greatly; competition from out-of-town outlets and the internet have contributed to uncertainty in the high street. Below is East Square and the site where the head post office was built and opened in 1963. Today it doesn't inhabit its original building and has been relocated to WHSmith.

This is a view of the East Walk as it joins Town Square. You can see where a Chinese restaurant was, sticking out on the left-hand side, in 2010. It was a silver service restaurant at first, which a young Tom King ate at with his parents. It then became the Red Lion Chinese restaurant before it was the How Wah Chinese restaurant. Below we see Stylo (Barratt) and Austin the Tailor in East Walk, Basildon, in the 1970s.

The block of forty-one shops facing Market Square were the first to be built in Basildon new town. Tailor and outfitter Mr Allan Henbest, whose shop was originally in Laindon High Road, opened the first shop on 16 August 1958. A clean, developing new town had a large proportion of young incomers, which is very apparent in this photograph of Sainsbury's with all the prams outside – many, no doubt, with babies in. Taylors department store is seen here in the 1970s.

Paul Nagle, Kelleys Radio, 1984. Paul managed the record shop in the 1980s, which had been in the Town Square since the 1960s then relocated to No. 14 Eastgate Centre. They sold cassettes, 7-inch singles and 12-inch albums, specialising in reissued golden oldies. They had the most extensive range of jazz, soundtracks, indie and vintage rock in the whole of Basildon. It closed in the late 1980s. Presto is seen below Sweeney's Discotheque in 1970. Sweeney's was at High Pavement until 1988.

The area of grass where Marks & Spencer was to be built in 1971 – it was constructed in the November of that year. In 2018 it was announced that the Basildon Marks & Spencer was to be closed as part of a major overhaul. It closed on 21 April 2018, the same day as the Toys 'R' Us superstore, which closed due to the company's fall into administration. Previously, in 2013, Blockbuster, a video rental chain, went into administration.

Basildon Market, 1966. For many years it was a thriving, mainly greengrocery and produce market, with friendly, knowledgeable traders; however, trade decreased when supermarkets became more convenient. After sixty years of trading at Market Place the market relocated to a more central position at St Martin's Square in 2018, as part of the new 'Basildon Town Centre Masterplan' that was approved in 2012. The picture below shows the empty market site in January 2019.

2
The Working Day

Harry George Moore with a prize-winning bull at Moat House Farm, Church Road, Basildon.

This is a map of the Basildon, Nevendon and Vange area surveyed in 1864 and 1873. You can see Basildon Hall (where East Thorpe is now), Middle Hall and Luncies Farm near Timberlog Lane, and Basildon Bull can be seen at the junction of Timberlog Lane. The Barge Inn can be seen at the bottom right. In the lower photo, further along the road from the public house, we see Saunders & Son the bakers, owned by George (Doughy) Saunders.

On 20 May 1937 Elizabeth Goodson paid a settlement of £2,643.06 for the lease of The Barge Inn and surrounding land. Elizabeth, an old-time queen bee, married local baker George (Doughy) Saunders, a formidable character. 'They were like the Elizabeth Taylor and Richard Burton of Vange,' recalls Elizabeth's niece, Geraldine. Sadly George died in an accident on a railway crossing on Geraldine's eleventh birthday. Above is George and his pony Enoch. Below we see Geraldine's parents, cousin Mary and husband Charlie Baker, and her auntie and uncle at the Connaught Rooms, Romford Licensed Victuallers Association.

In 1945 Elizabeth invited Geraldine's dad and pregnant mum to take over the pub. Sadly, Geraldine's mum died twenty years later, so she decided to work with her dad rather than pursue her career, as her heart had always been in the pub. Above we see Geraldine's christening celebration in The Barge with her parents Angela and Ted Gahan and their extended family. Below are Geraldine and bar staff Sharon Hayward, Jackie Stock-Baker, Shirley Ansell, Betty Barker, Margaret Price, Sharmon Szewczyk and Barbara Smith.

On 6 June 1999, Geraldine and her staff took the pub back to VE Day 1945, to commemorate the party her father hosted fifty-four years before. This was part of the local village fair they hosted with St Chads Church. They raised £4,000 and The Barge won Pub Promotion of the Year in 2000. Sadly Geraldine's husband Graham, who was the licensee, died in 2004. Geraldine Evans JP wanted to buy the pub, her family's home of seventy years, but the pub company refused. After a huge struggle she eventually secured a thirty-year lease, but left in 2007. As 95 per cent of the turnover was beer, she realised she would save up to £800 a week if she had been able to buy the beer from the free market rather than having to buy the company beer. Geraldine said, 'The change of the licensing laws saw that the hours increased right at the time when people's spending money decreased, a nail in an already crumbling coffin for boozers!' The Barge finally closed its doors in 2015.

T. E. Thomas & Sons Garage, London Road, Vange, *c.* 1950. A high position and its surrounding 100-acre site brought Wootton Farmhouse to the attention of West Ham Borough Council when they were looking for somewhere for a sanatorium for children with tuberculosis. It was opened on 26 October 1927 as West Ham Sanatorium by the Mayor of West Ham, Alderman Ernest Reed. It closed in the 1950s. We can see the back view of the farmhouse in 1915.

This was a typical plotland dwelling in Butlers Grove, Langdon Hills, in 1958 – an escape from the 'Big Smoke'. At first they were used for weekend breaks, but many families moved down permanently during the two world wars. Mrs Mary Ellen Chataway was the owner of a large farm and castle-like house called Castlemaine, on top of the hills at Lee Chapel. Working on the farm she'd wear torn, dirty clothing, but would dress up in expensive clothes and jewellery when in London.

Puckle's Farmhouse and its 62 acres of land located on the Wash Road, Laindon, was left to St Nicholas Church in John Puckle's will dated 6 May 1617. The trustees of the will were to find a schoolmaster to teach the poor children of 'Baffeldon' or 'Layndon'. A sixteenth-century priest house attached to St Nicholas Church became a school called Puckle's School for 250 years. The last schoolmaster, James Hornsby, was born in 1800 without the lower part of his left arm.

SOLI DEO GLORIA
Iohn Puckle of this parish by his laſt will dated the 6.may 1617 Gave all his Copyhold lands to the maintenance of a School maſter, for teaching a Competent number of poor children of Baffeldon or Layndon: The Salary to be paid half yearly by the truſtees uizt. Five pounds upon the feaſt of the Annunciation, and five pounds upon the feaſt of faint michael: This charity is to be Commemorated yearly upon the feaſt of faint Iohn, upon which day the pious Founder, of happy memory, hath apointed an anuall fermon and the fee of a mark to the preacher for ever. Memoria Juſti beata eſt in fecula feculorum fol: 10: 7: Amen.

Manor House, Laindon.

Mr William Johnson Sloper bought his family and a herd of cows by rail to King Edward Road, Laindon, from near Winchester in around 1906 when his son, Sidney Frederick, was six months old. The dairy company W. Sloper & Sons built up milk rounds, delivering to some 200 inhabitants. Later they moved to Manor House (Great Gubbins) on Manor Road. Below is a view from the Station estate up to St Nicholas Church, where you can see the cows grazing.

VIEW FROM STATION ESTATE, LAINDON.

Sidney Sloper left Langdon Hills School at fourteen and started to deliver raw milk in churns on his horse and cart twice a day. Later on he used a motorbike with a side car. William and Sidney are seen with an old-style delivery van. At some point William sold his dairy herd. The Slopers were the last family to live in Manor House before it was demolished. Sidney had a dairy built in Laindon High Road that was known as W. J. Sloper & Son.

By now Watch House Farm in Wash Road supplied the milk, which started to be bottled in 1933. Sidney married Mabel in 1935 and they lived above the shop (see page 17). They had two sons, John and Peter. Peter joined the company in 1959 and a year later he bought a Ford 100E van for deliveries. Peter is standing with a show (Ford) van. Inside the van are artefacts from the olden days, such as old churns and milk bottles.

In 1969 the Basildon Development Corporation compulsorily purchased the dairy in the High Road so Peter joined forces with Ray Whife. Whife & Sloper traded at Markhams Chase for thirty-four years until 26 April 2003 when the dairy closed. Here is Andy Savage, Jim King, Ray Whife, Peter Sloper and Dave Lindsey on the last day. Sadly, in November 2003 Ray Whife died. Dairycrest purchased their customers and Peter continued working with them for seven years. Peter now shows old vintage vans and milk floats at events around the country.

In the 1950s milk was pasteurised and Charles Markham, together with most of the other local dairies, including W. J. Sloper & Son, invested in a processing plant built in Cranes Farm Road. It was called South East Essex Wholesale Dairies, the first factory to be built in Basildon, continuing until the 1970s. The factory is in the foreground of this aerial photograph. Below, Maycock's Poultry Farm *c.* 1910, at the junction of Pipps Hill Road and Rectory Road, as it was then.

Ford Motor Company opened a radiator factory in 1957 at No. 1 Industrial Estate. Frank Newton worked at Ford Radiator Plant for thirty-three years. It later became the Visteon Radiator Plant, which closed down *c.* 2009. The corten steel sculpture, affectionately named 'The Pineapple', was created by William George Mitchell in 1977 for Ford Motor Company and was displayed in front of its UK headquarters at Trafford House, Cherrydown. It was reported missing in 2012 by Colonnade, the redevelopers of Trafford House.

In 1984, Tanqueray Gordon & Co. Ltd, the makers of Gordon's gin, moved their British production to Laindon. It had a purpose-built distillery and bottling plant that occupied 26 acres and cost £48 million to build. After only fourteen years in Laindon the company began a closure programme, which was completed by 2000. The British production of the company moved to Fife, Scotland, in 1998. Ilford Films *c.* 1960 is seen below.

In 1879 Ilford Photographic Company's humble beginnings were in the basement of Mr Harman's house in Cranbrook Road, Ilford. As the company grew they branched out to different parts of the country. The Basildon factory processed Ilford's colour films. By 1964 it also produced colour prints, did colour printing from transparencies and manufactured chemicals and equipment. Bonallack's, the coach builders, relocated to Basildon from Forest Gate in 1953. Observe all the vehicles from the 1960s in both of these photographs.

43

The Basildon Council building and library at Fodderwick in the 1980s. Below we have a view of the same buildings taken from the roof of Marks & Spencer in 1997. Fodderwick led to the road that went past the theatre onto the Roundacre roundabout. The Westgate Shopping Centre is now built on this site and the council offices are in the Basildon Centre, next to the Towngate Theatre on St Martins Square.

Roy Davis stood on top of the theatre roof in 1996 to take a picture of Fodderwick leading to Pagel Mead. This road used to run in front of the Towngate Theatre. These areas are pedestrianised now. Yardley London was established in 1770 and branched out to Basildon in 1966, occupying a 19-acre site. Roy's mother worked there when they celebrated their 200th anniversary at the Albert Hall.

Roy Davis was a security guard at Yardley's for twenty-three years. He locked everything and put the key through the door on the last day in January 1999. He met his wife Brenda at Yardley's, and four of their children worked there. They had long-service awards dinners held in the staff canteen, a social club with snooker table and darts, opening at lunchtime and in the evenings. They also had a football team and a sports field.

Tom King was employed as a feature writer at the *Echo* newspaper in 1989 when they still had a printing press, which occupied an entire floor of the Chester Hall Lane building. The evening newspapers started printing around midday. The building vibrated slightly, then gradually the noise would get louder and louder, like an aeroplane noise. 'It never really lost its magic,' Tom recalls, 'these amazing machines would be spinning out papers.' *Below, Tom is reporting on the 1993 Southend Air Show aloft an aeroplane.*

Everything was reorganised around 1990 when the presses were sold to Africa, the *Echo* then used the *Financial Times* presses in East London. Today there are six reporters, compared to forty-two when Tom joined in 1988. Tom is seen in Strasbourg in 1992 reporting on the European Parliament in reference to Essex with the two South Essex MEPs, Anne McIntosh (left) and Patricia Rawlings (right). On the left, Tom is with fellow feature writers Kelly Buckley and Emma Palmer on his last day at the *Echo* in 2015.

3
Transport

Basildon Bus Station, Southernhay, 1960s.

Arthur Greave and Cyril Toakey of the Vange Fire Brigade, 1940s. A Westcliff bus stands outside The Old Barge Inn. Geraldine Evans, whose family ran the pub for seventy years, recalls a resident ghost known as William. He may be the spirit of William Benton, a licensee in the early 1840s, or he could be the ghost of a stranger, found dead on the Barge's premises in 1832.

An early picture of Pitsea station and Masters House, *c.* 1900. At this time the railway cottages, which housed the staff, led up to the station. In 1910 the ordinary return fair was *3s 6d* and a season ticket cost £3 15*s* a quarter; in 2019 you pay £807.10 for a three-month season ticket. Below we can see the Pitsea booking office in 1964, a glamourous pin up of a woman can be seen near the clock.

A steam train passes by an estate being built in Basildon. There have been three Pitsea rail accidents recorded. The first known accident was of George Saunders in October 1956 on an unmanned level crossing. The second was in April 1961, which hit the headlines – one death was reported but another happened later in hospital and there were many casualties. The third happened in July 1961 when a passenger train hit a tipper lorry on the Pitsea Hall level crossing.

In 1890 Campbell's started out with horse-drawn vehicles in Pitsea. They eventually had a fleet of eighteen vehicles. Brothers Dick, Jack and Albert became directors when Campbell's Motor Services became a private company in 1934, but still drove the buses and knew their passengers by first name. Pat Mundy remembers sharing the Campbell bus from Pound Lane to Wickford Market with chickens and goats. Some of the Campbell family are seen in the lower picture.

A view of the High Road at Pitsea looking towards the Anne Boleyn mansions *c.* 1950. On the right is a Howard Dairies vehicle. On the left is an old-style coach, possibly a Campbell's one. Below we see a fine Langdon Hills race horse, trained by the father of Sonny Firman and owned by Sir Joseph Dimsdale of Goldsmiths in the 1900s. Dimsdale was the Lord Mayor of London in 1902 and an MP for the City of London from 1900 to 1906.

Parkinson's carnival entry stands outside their garage on the High Road at the corner of Somerset Road. Mr Parkinson started the business after the First World War, which his sons Cliff, Bert and Cecil continued. In the 1940s an Austin 7 is seen in the foreground of the picture below, and the van seen on the left could be a bakery van.

A steam train in Laindon station travelling towards London. Below we see the Laindon station staff of 1920. John Sims was the proud stationmaster of Laindon station from 1926 to 1952. When he took over the station it was lit by oil lamps and had a staff of nine, but nineteen worked there when he left. John was the father of the famous film star and comedian Joan Sims. He was known as 'Joan's Dad'.

Estate agent Mr F Foulger stands at Laindon station, ready to meet prospective plotland purchasers in the 1910s. Below we see a petrol tanker outside Toomey's, Laindon, in 1929. In 1914, Winston Churchill, First Lord of the Admiralty, argued the case in Parliament that Britain needed a dedicated oil supply. The resolution was passed and the UK government became a major shareholder in the Anglo-Persian Oil Company. In 1922 the oil company marketed motor spirits through British Petroleum.

The charabanc (pronounced 'sharrabang') was more commonly seen on our roads up to the late 1920s for sightseeing or work parties going to the seaside or the countryside. Below is Old Tom's bus. Old Tom's Motor Services was a valuable transport service remembered by many an old Laindoner. Tom Webster started his business in 1921 with a single Ford charabanc that he drove himself.

Early transport from Laindon station was provided by Mr Dick Hillman by pony and trap, then later Fred and Sid Hinton converted a lorry into a bus. After this, Fred Hinton bought a red London bus with an open-top deck. On the lower picture the nearest double decker is advertising 'The New Hillview Estate Bungalows,' designed by the architect A. J. Varndell *c.* 1922.

Syd Farmer's office and taxi, 1950. The artist William Gordon designed the original 314-foot mosaic around 1960, above the Blenheim House shopping block at South Walk. When this photo was taken in 1987 the bus terminus had undergone extensive renovation to create an enclosed walkway. The mosaic was replaced in October 1991 with a 300-foot timeline of Basildon, which was designed by Fewster & Partners of London and installed by Hollybush Construction.

4
Leisure and Activities

Laindon Berry Boys Club, with trophy, 1970s.

Vange swimming pool, Merricks Farm, 1930s. Joyce Whitelock's aunt and uncle, Mr and Mrs Cook, owned Gouldings Farm next to the swimming pool. There was a polio scare and Joyce and her cousin were banned from going to the pool as the water came from the creek. They would sneak in through a loose board in the fence. A boy she knew got polio and had to have an iron lung, which was like a metal coffin. Fortunately, he survived.

Joyce Whitelock's grandparents, Mr and Mrs Flitch, bought a plot of land in Timberlog Lane for £5 in the 1920s. Mr Flitch built a bungalow, which he sold and bought another plot in Whitewater Avenue. Later it was compulsorily purchased for £1,200, which Joyce thought wasn't bad for a detached two-bedroomed bungalow with a large plot of land. She remembers Hope Hall, seen in the foreground, and Gordon Hall, further back. Below is the original Bull Inn, Vange, c. 1900, which was demolished in 1961.

The shop and houses have gone now from London Road in Vange, but Vange School, seen in the distance, still remains. The Old Barge Inn would draw in travellers to come and eat the freshly landed eels, caught just a few hours earlier in the marsh creeks. In the 1700s, famous highwayman Dick Turpin was a member of an Essex gang who used an ancient smugglers' path that ran over the marsh to a well-known smugglers' trading post.

Old Thatched Cottage, High Road, Vange, which stood on the north side of the road near the top of Paynters Hill, *c.* 1910. At one time Paynters Hill was part of the course of London Road. Sometime around 1929 it became a separate road as the county council approved a bypass proposal to realign London Road. There is a bus stop called Paynters Hill opposite an alleyway that leads to Paynters Mead. Below is the Highland Estate, Vange.

Here we see a garden party at Basildon Rectory, Rectory Road, Pitsea, c. 1937. Revd Reynolds and his wife had one each summer. Joy Barrett is the little girl sitting near the middle of the picture. The rectory was demolished around 1960. A young girl is seen walking down Brackendale Avenue, Pitsea. David Coubrough remembers that children played out in the street, going home at dinnertime with no fear of getting harmed.

At one time Rectory Road was a very lonely place. There were only a few buildings, such as the Rectory, Chalvedon Hall and a farmworkers' cottage. There were no more buildings until Burnt Mills Farm was reached. In 1949 you would have seen this barn in Rectory Road. Today it is an urban road between housing estates.

Matthew Lane played up at St Michael's Church with his friends as a child and witnessed how it quickly turned into ruin. A grave near the tower had fascinated them. It was presumed to be a witch's grave as it read: 'Here lies a weak and sinful worm the vilest of her race.' In 1998 the nave and chancel was demolished, and just the tower remains, which supports a mobile phone mast. Below is a modern view from the mount towards the creek.

SCENE FROM LAINDON HILL, NEAR HORNDON.
ESSEX.
THE PROPERTY OF MRS S. HATTON,
TO WHOM THIS PLATE IS RESPECTFULLY INSCRIBED.
Published by Geo. Virtue, 26, Ivy Lane, March 1, 1832.

This picture was drawn by W. Bartlett and published by George Virtue in 1832. The area is part of Langdon Hills Country Park now, which has miles of walking and cycling paths that go through parkland and farmland. Ancient woodland is surrounded by vast carpets of bluebells from April through to May. The photograph is taken from a similar spot in 2018.

Nore View, Nore View Crescent, Langdon Hills *c.* 1920. It was built by Mr Dolman around 1890, then sold to Mrs Mary Ellen Chataway in 1924. It was mysteriously burnt down when she was away visiting friends. The Berry Boys Club was started in 1946 by Fred Nunn of Berry Lane and was the longest established boxing/football club in the area. In the picture an army cadet appears to be showing weapons to the boys. The Berry Boys Amateur Boxing Club folded in 2016.

The Fortune of War, Laindon, *c.* 1929 and in the 1950s with its forecourt half full with coaches. Harold and Ann Topson managed the hotel and pub from 1937 to 1941 and lived there with their children John and Stan. John recalls that his dad wrote a long essay about life at the time, mentioning lots of coaches stopping there en route to Southend, and how busy it was. An article was published in the *Echo* newspaper when Jim Worsdale was editor.

The Laindon Hotel, 1980s. It was built in 1896 for £3,310 by a syndicate in connection with a proposed racecourse, which never materialised. It had its own bunny girls in 1969 and in the early 1980s a local chart act called The Pinkees entertained the locals. The hotel closed in the late 1980s and was demolished in 1991. Pictured below is a derelict Basildon (Barstable) Hall in the 1960s, an ancient moated building that featured in the Domesday Book. It was demolished in 1961.

Members of the Royal British Legion on Armistice Day at St Alban's Hall, Church Road, Basildon. Joy Barrett's mum was secretary of the Basildon branch. Bernard Braine MP is standing next to the vicar, Mr Reynolds, on the left of the picture. Sir Bernard Braine, Baron Braine of Wheatley (24 June 1914 – 5 January 2000), was a well-respected Conservative MP and a member of Her Majesty's Most Honourable Privy Council. Below is St Alban's Church Hall, Church Road, Basildon.

Aquatels Zoo and ecology centre, 1970. The land was acquired by compulsory purchase order and quite a few people were forced to sell. There is a story of seventy-five-year-old Margaret Hughes who shared a detached house and an acre of land with her two sisters and niece. While bailiffs and their accomplices ripped off doors and smashed windows, Margaret stood firm and continued cooking the evening meal. In 1997 the Festival Leisure Centre was built in its place.

Great swathes of Gloucester Park were lost to housebuilding, including the championship-sized swimming pool designed by Ken Cotton. The £437,000 post-modernist building opened in June 1968 with a special ceremony – eighty-six children selected from every school in Basildon jumped in. Vin Harrop led a passionate campaign to save it in 2007, but sadly its doors finally closed in April 2011. Vin managed to get a plaque installed by the developers to signify where the pool once stood.

Demolition of the swimming pool Gloucester Park, Basildon, October 2011

Gloucester Park Swimming Pool and Parklands Centre was pulled down in 2011. Basildon Council sold the old pool site for £4 million to Barratt Wilson Bowden, who planned to build 519 homes in its place and on surrounding parkland. Murrayfield Pavilion, which was built in 1967 and provided changing facilities, refreshments and a cricket scoreboard for county class cricket matches, was also demolished in 2010.

The demolition of Gloucester Park Swimming Pool and the boating lake before it was drained. Basildon Council and Barratt Homes have now immortalised the late Kenneth Cotton's name with a bronze plaque set into the patio of the new artificial lake within the new housing estate. Ken was former head of Basildon Council's Architects' Department and an Associate of RIBA. He was married to architect Trena M. Cotton, who designed St Martin's of Tours Church. Below is the Barratt Homes development.

Dave Chapple's sculpture, *The Woodsman Poacher*, had stood in St Martin's Square since 1996, but was moved into storage by the council in 2010, which provoked public uproar. As a conciliatory move, it was replaced by Chapple's stone sculpture *King Edgar's Head* in 2010, although its position had noticeably changed in 2018. At the entrance of Brook House was the 6-foot bronze statue of the Greek poet Homer in 1962. It went missing in the 1990s and hasn't been seen since.

In recent years too many public houses and venues that were once very popular have been forced to close. The Commodore in Timberlog Lane, in the Barstable area of Basildon, first opened in 1962. It had a restaurant and live entertainment such as Saturday night dinner dances. Rick and Barbara Mundy had their engagement party there. It closed its doors *c.* 1999 and was demolished in 2000 to make way for Commodore House, a residential development of twenty-four flats.

The Roundacre was marked on a Basildon Development Corporation map as a Roman Catholic Church Hall, but was better known as a centre for live bands and a meeting place for young people from the 1970s. When the site was earmarked by Basildon Council for a place to build twenty flats it was a sad day for Tim Williams and his peer group. He said, 'They will never forget time spent there during their youthful rebellious years, fighting mundanity and creating their own special culture.'

Sue Paget, Alison Moyet and Kim Forey had been singing together for a while. They had heard that if you got up and played at the Roundacre youth club you would get a free drink, so they sang an old family song, 'My Friend the Sun'. That's how they got started, and they formed the Vandals. These photographs of the demolition were taken by Tim Williams, Depeche Mode's first photographer.

5
Entertainment

Geraldine Gahan as Pitsea and Vange Carnival Queen in 1967.

Geraldine Gahan (later Evans) was the Pitsea and Vange Carnival Queen in 1967. She is seen on a horse-drawn dray wagon on Basildon Carnival day. The carnival was very big back in the 1960s, with the Basildon Court visiting other carnivals in Essex every Saturday throughout the summer. As Carnival Queen, Geraldine got sent to Berlin when the Berlin Wall and Check Point Charlie existed. Below we see Geraldine, Christine and Kerry-Ann meeting Radio London ('Big L') DJ Mark Roman at Romford Carnival.

'Doughy' Saunders, Basildon's most famous baker, used to head up the Vange Carnival procession dressed as John Bull, a tradition that went back at least as far as the Napoleonic Wars. Below is J. W. Campbell's decorated cart in the Pitsea and Vange Carnival in the 1930s. They were the most well-known transport company of that era in Pitsea, a familiar sight outside Pitsea station.

In the top picture we see the Whife & Sloper Ltd entry into the Basildon Carnival in the 1990s. Below is the float in the Pitsea and Vange Carnival. They also involved a pedestrian milk carrier, which was often used for the more difficult muddy tracks and not seen these days. They received the Eileen Noble Trophy for Trade Entry Local and National, which was presented by the Pitsea and Vange Carnival Association.

85

Joan Sims is seen here, fourth from the left in the back row, with the Laindon & District Amateur Operatic & Dramatic Society, which later became the Basildon Operatic Society. Sadly the very funny Joan Sims isn't around anymore. Her first taste of acting was putting on impromptu performances on the platform of Laindon station as her father was the stationmaster. Below we see Jonathan Chelton protesting about the closing of the Century Cinema.

Tom King used to cycle down from Wickford to the Century, formerly the Broadway, in Pitsea to watch ancient films. He thought they were fleapits by then – smoky and nearly always empty. Tom recalls that the old Arts Centre was a wonderful place under Vin Harrop; it was really alive. They used to take their children there on a Saturday morning to see Disney films. Below is the Arts Centre in 1986 to the right of the picture, taken from where the Towngate Theatre stands now.

The Arts Centre was a melting pot for musical activity, plays and drama workshops, international and children's cinema, local and national art exhibitions and art workshops. Vin Harrop is standing with Reg Miller, theatre technician; Mary Elam, usherette; and Ted Elam, their handyman, wearing a suitable costume for a week-long 'Olde Tyme Music Hall' that he produced in *c.* 1970. Members of the audience were invited to dress up and a good time was had by all.

The demolition of the Arts Centre (called the Towngate Theatre in 1988) with the tower of the new Towngate Theatre in the background. Many amateur dramatic groups used to rehearse in the original building. Tom King and his family went to Robins Cinema (formerly ABC) to see the film Mousehunt. Tom said, 'It was the middle of winter and they hadn't got the heating on, the family ran business was obviously close to bankruptcy.'

Big award for 'Pop' group – One of the best in the country, that's the 'Expression' resident beat group, at the Locarno Ballroom, Basildon'. This was the front-page headline of the *Basildon Standard Recorder* on 25 October 1968, which sold for *5d*. They had received a silver cup as the second best resident group out of seventy-eight bands throughout the Mecca circuit.

Mecca Leisure Group ran numerous nightclubs in major towns and cities throughout the UK. After playing on the Mecca circuit, Expression, later Sadie's Expression, became the Basildon Mecca's resident band and had several record deals and single releases in the UK and in Europe. Band members Hugh Thomas, John Skelton, Michael Drewer, Chris Brown and Michael Harding are seen standing on the Locarno rooftop. The pre-fame Dave Clark Five were also Basildon Mecca's resident band in the 1960s.

The Vandals on a photoshoot in Basildon. In 1978 punk exploded onto the music scene and Alf (Alison Moyet), Sue Paget and Kim Forey decided to form a punk band. With guitarist Rob Allen (now Marlow) and two different drummers, Simon Kirk then later John Dee. Their music was described as 'simple, basic, three chord, breakneck speed punk anthems' by *Some of That* fanzine. The group lasted over a year before Alison, Sue and Rob joined different bands.

The Vandals playing at the Basildon Rock Festival in 1978. Alison Moyet placed an advert in *Melody Maker* in 1982 and Vince Clarke replied. He'd just left Depeche Mode and she'd known him since she was eleven from a Saturday morning music school. 'Passionate vocals meets cool electronics,' was a description that Yazoo modelled, an influential duo in the 1980s, albeit short-lived. Alison went onto a very successful solo career and Vince Clark later joined Erasure.

Here we see the interior of Raquels in the 1980s, which was formerly the Locarno Ballroom. Depeche Mode played there in 1981 and have since sold over 100 million records worldwide. Below is an invitation to 'A Patrons Ball' to be held at the Locarno Ballroom in 1967 with resident band The Expression (Sadie's Expression). After a tragedy, Raquels, the iconic nightclub, closed on Friday 29 December 1995. After several incarnations it has remained empty since 2014.

The Directors of
MECCA DANCING
and
Mr. R. WINKFIELD
(General Manager)
have much pleasure in requesting your company
on the occasion of
A PATRONS BALL
to be held at the
LOCARNO BALLROOM · BASILDON
on FRIDAY, 8th SEPTEMBER, 1967

Non-stop dancing to
THE EXPRESSION

8 p.m. — 1 a.m.

This invitation to be exchanged at the Box-office
(Issued subject to Rules & Conditions of the Ballroom)

Bibliography

Hill, Marion, *A Century of Basildon* (Stroud: Sutton Publishing, 2000)
Hill, Marion, *Basildon in Old Photographs* (Stroud: Sutton Publishing, 1999)
Lucas, Peter, *Basildon* (Bognor Regis: Phillimore & Co. Ltd, 1991)
Lucas, Peter, *Basildon: Birth of a City* (Imprint unknown, 1986)
Payne, Jessie K., *Basildon A Pictorial History* (Bognor Regis: Phillimore & Co. Ltd, 1981)
Reeve, Jim, *Basildon, Then & Now* (Stroud: The History Press Ltd, 2012)
Thompson, Russell, *Basildon: Living Memories* (Gillingham: Frith Book Company Ltd, 2002)

Websites

www.basildon.com/history/home.html
www.e7-nowandthen.org
www.gracesguide.co.uk/Anglo-Persian_Oil_Co
www.laindonhistory.org.uk
www.photomemorabilia.co.uk/Ilford/Chronology.html
www.sadiesexpression.co.uk/page3.html
www.southendpunk.com/html/soutpunk.htm
www.southendpunk.com/html/suepaget.html
www.theguardian.com/music/2013/apr/18/alison-moyet-smashed-gold-discs
www.yardleylondon.co.uk/media/our-world/Yardley-London-Historical-Timeline.pdf
www.echo-news.co.uk

Acknowledgements

Many thanks to everybody that I interviewed face to face, by phone or through the internet; you made my research so real and interesting! Thank you Geraldine Evans, Peter Sloper, Tom King, Roy Davis and Pat Mundy. Also, Joy Barrett, Joyce Whitelock, David Coubrough, John Topson, Paul Nagle, Tim Williams, Vin Harrop, Geoff Martin, Steve Chelton and Matthew Lane. I would also like to thank the Basildon Borough Heritage Society, my husband for his support and my publisher, Amberley Publishing.

My sincere gratitude to the following for allowing me to reproduce photographs in the book: Reproduced by courtesy of the Essex Record Office: the engraving, reference I/Mb 205/1/7, page 69 (Top), Ordnance Survey Map page 29 (Top). Joy Barrett: 66 (T), 73 (T), 73 (Bottom). Matthew Lane: 68 (T). Paul Nagle: 25 (T). Peter Sloper: 17 (T), 17 (B), 36 (T), 36 (B), 37 (T), 37 (B), 38 (T), 38 (B), 38 (inset), 39 (T), 39 (B), 85 (T), 85 (B). Roy Davis: 44 (B), 45 (T), 45 (B), 46 (T), 46 (B), 60 (B), 87 (B), 89 (T). Steve Chelton: 86 (B). Geraldine Evans: 29 (B), 30 (T), 30 (B), 31 (T), 31 (inset), 31 (B), 32 (T), 82, 83 (T), 83 (B). Sue Ryder Paget: 92 (T), 92 (B), 93 (T). Tim Williams: 76 (T), 76 (B), 77(T), 80 (T), 80 (B), 81 (T), 81 (B). Tom King: 47 (T), 47 (B), 48 (T), 48 (B). Vin Harrop: 88 (T). John Skelton: 90 (T), 90 (B), 91 (T), 91 (B), 94 (B). Geoffrey Martin-Smith: 5 (T), 54 (T), 63 (T), 63 (B), 64 (T), 64 (B), 65 (T), 65 (B), 66 (T), 67 (T), 67 (B), 79 (T), 88 (B). Frank Newton: 41 (T). Ian Clarke: 75 (T). The author, Lisa Horner: 20 (T), 26 (B), 27 (B), 32 (B), 35 (B), 68 (B), 69 (B), 74 (B), 77 (B), 78 (T), 79 (B), 96 (T), 96 (B). The rest of the photographs are from the Basildon Borough Heritage Society.

The author with her parents in 1966.

My Nan, Amelia, told me something that shocked me. That as a child in the early 1900s she often went with some of her eight brothers and sisters to Smithfield Market and dived under the stalls to collect scraps of meat. Great-nan would make a stew from it that would last for days. Nan would share her memories, which fed my curious mind, sparking my interest in history.